FIRESIDE

Rockefeller Center

1230 Avenue of the Americas

New York, NY 10020

First Fireside Edition 2002

Originally published in 2002 in Great Britain by Ebury Press, Random House

Published by arrangement with Random House Publishing Group

For information regarding special discounts for bulk purchases,

please contact Simon & Schuster Special Sales at 1-800-456-6798

or business@simonandschuster.com

Manufactured in Singapore by Tien Wah Press

10 9 8 7 6 5 4 3 2 1

Library of Congress Cataloging-in-Publication Data

Dallas, Sarah, 1951-

Vintage knits: 30 exquisite vintage-inspired patterns for cardigans, twin sets, and

crewnecks / Sarah Dallas with Yesterknits Museum. — 1st Fireside ed.

p. cm.

1. Knitting—Patterns. 2. Sweaters. 3. Vintage clothing. I. Yesterknits Museum. II. Title

TT825.D34 2002

746.43'20432—dc21 2002021000

ISBN 0-7432-2456-6

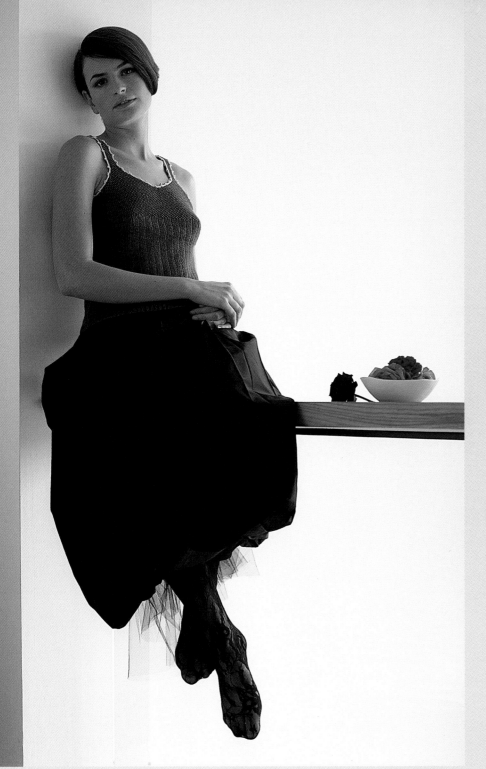

SARAH DALLAS

WITH YESTERKNITS

PHOTOGRAPHS BY CATHERINE GRATWICKE

A FIRESIDE BOOK
PUBLISHED BY SIMON & SCHUSTER
New York London Toronto Sydney Singapore

VINTAGE KNITS

30 EXQUISITE VINTAGE-INSPIRED PATTERNS FOR CARDIGANS, TWIN SETS, CREWNECKS AND MORE

Contents

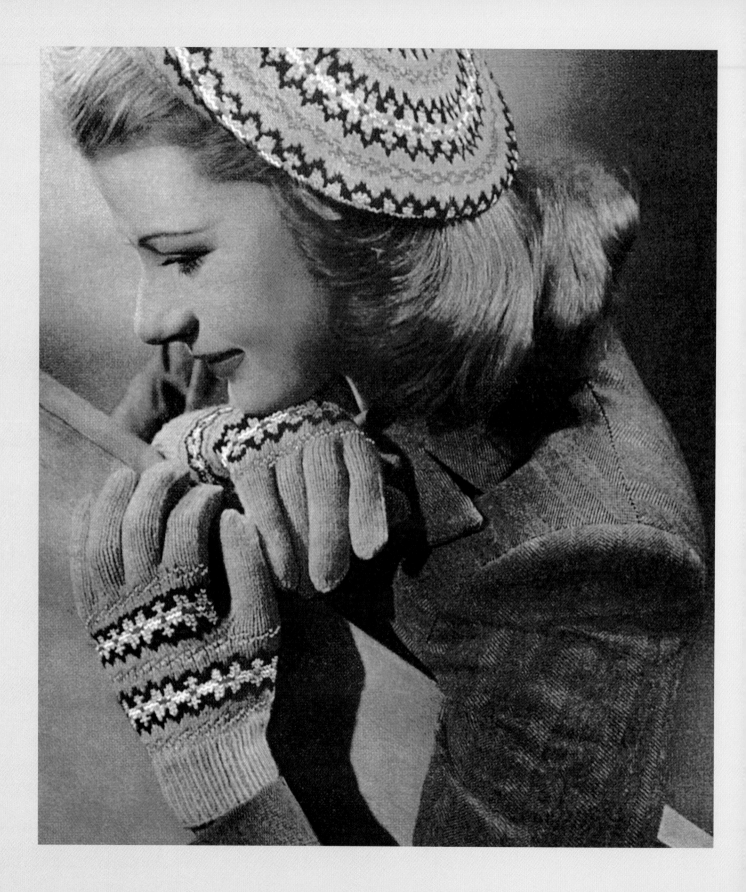

Introduction

The craft of knitting provides the wonderfully satisfying experience of creating something with your own hands. You are in control from start to finish, making the fabric and the garment simultaneously from a simple thread of yarn.

The period spanning the 1940s and the 1950s continues to be a source of inspiration for the knitwear designer. At the time, knitting was more than a hobby—it was a necessity, a common skill that enabled families to provide for themselves. All that was required was a ball of wool, a pair of knitting needles and some time.

Almost any article of clothing could be knitted, from underwear to sweaters, skirts, dresses, jackets, coats, and accessories. When a sweater wore out, it was unraveled and the yarn used again. The ingenuity displayed in some of these garments is simply extraordinary, to say nothing of the skill involved in the shaping and construction. Both were all-important at a time when the choice of yarn colors and textures was limited. This meant that the structure of the knitted fabric and the garment-making itself were essential to producing what you wanted and needed. These were fashionable garments and the knitters liked to show their expertise.

It is these elements that have endured the test of time and have been reworked in the modern and contemporary knitwear you see in the following pages. The designs shown here marry many of the details of designs from the forties and fifties with contemporary yarns and color combinations. The color choices, inspired by flowers, bring a vibrant and cohesive look to this fabulous collection.

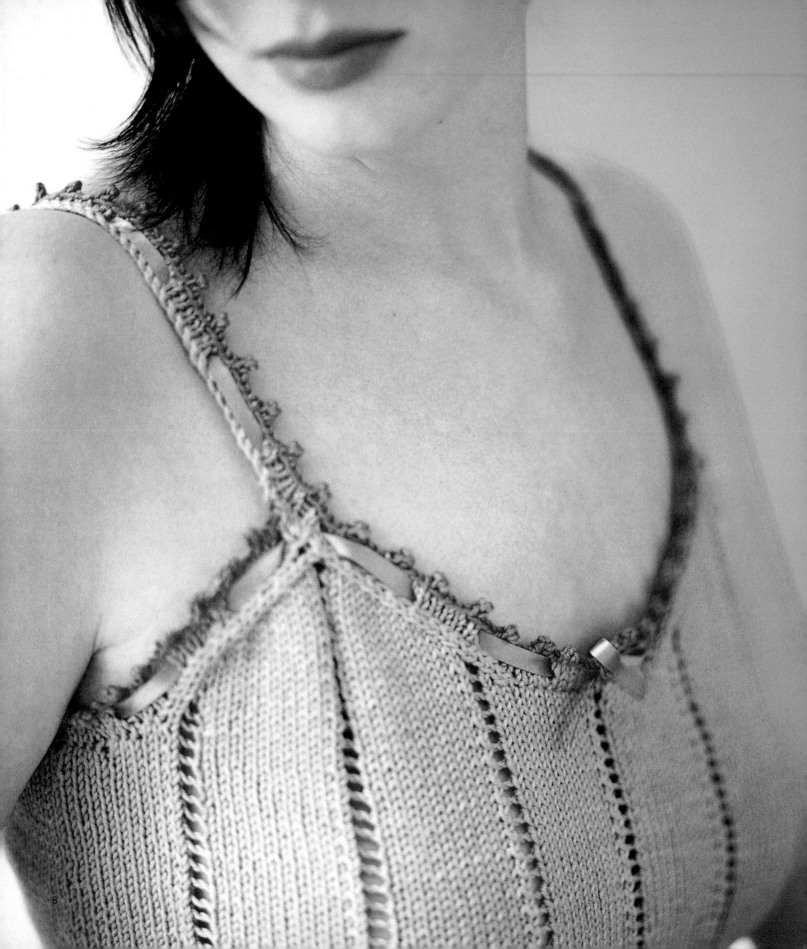

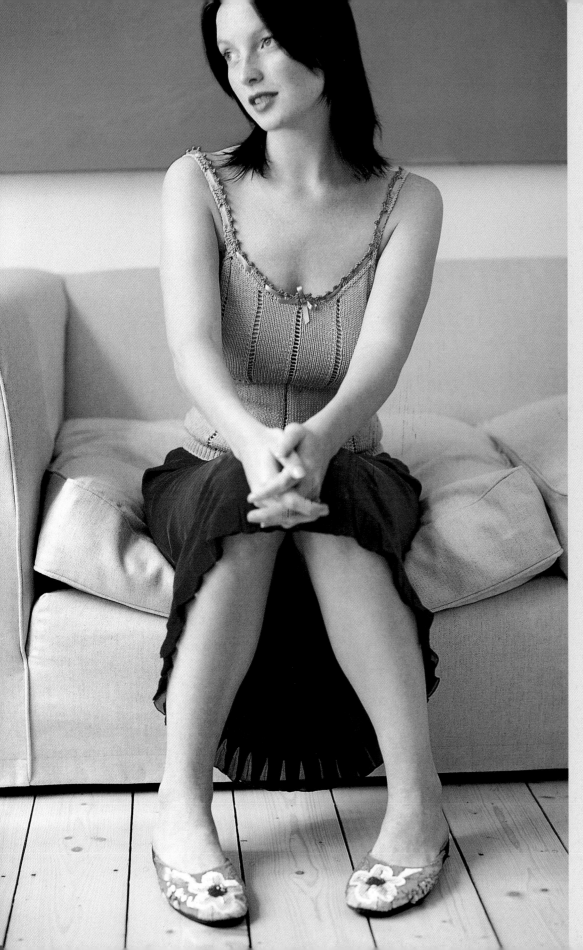

Lace camisole

SEE PATTERN ON PAGE 68

There's something very sexy
about this ultra-feminine lacey
knitted camisole. Maybe it's the
pattern of the pointelle knit,
maybe it's the satin ribbon
threaded through the pretty
trim. Whatever the reason, it
translates beautifully into an
alluring little camisole top
for modern living.

Cotton jacket with chenille edgings SEE PATTERN ON PAGE 70

There is a much wider range of yarns available now than during this period. The use of chenille
to edge this knitted cotton jacket adds texture and style to this very practical garment.

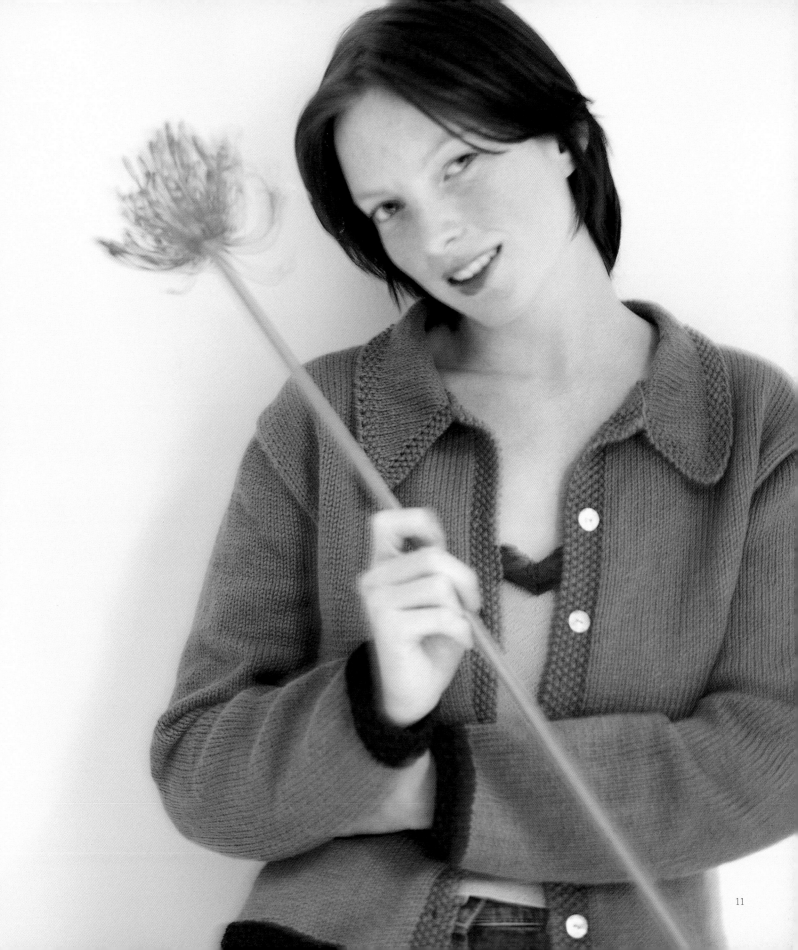

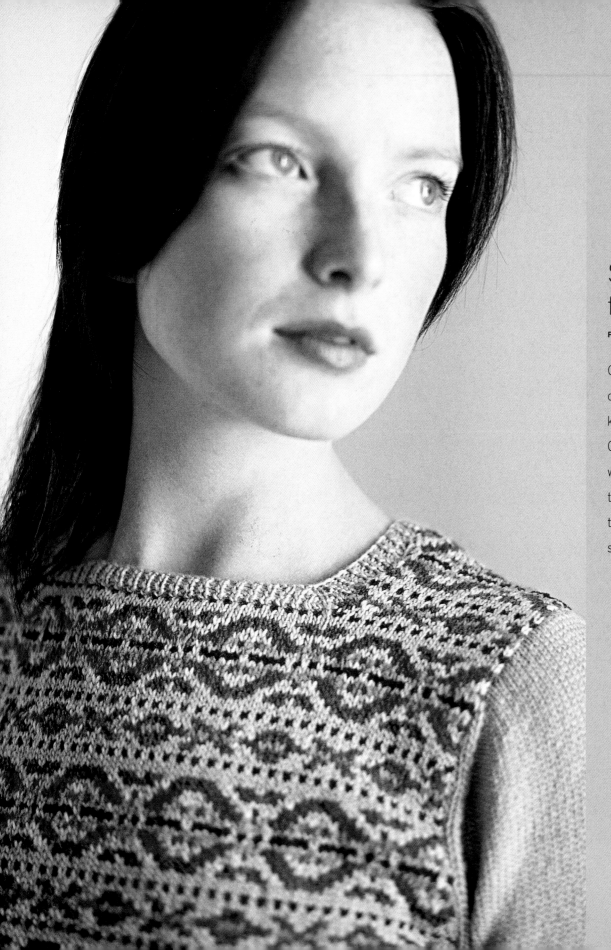

Short-sleeved fairisle sweater

PATTERN ON PAGE 72

Only small quantities of several colors of yarn were required to knit fairisle garments. Oddments of wool, never wasted, were gathered together to knit sweaters as shown in this up-to-the-minute short-sleeved fairisle sweater.

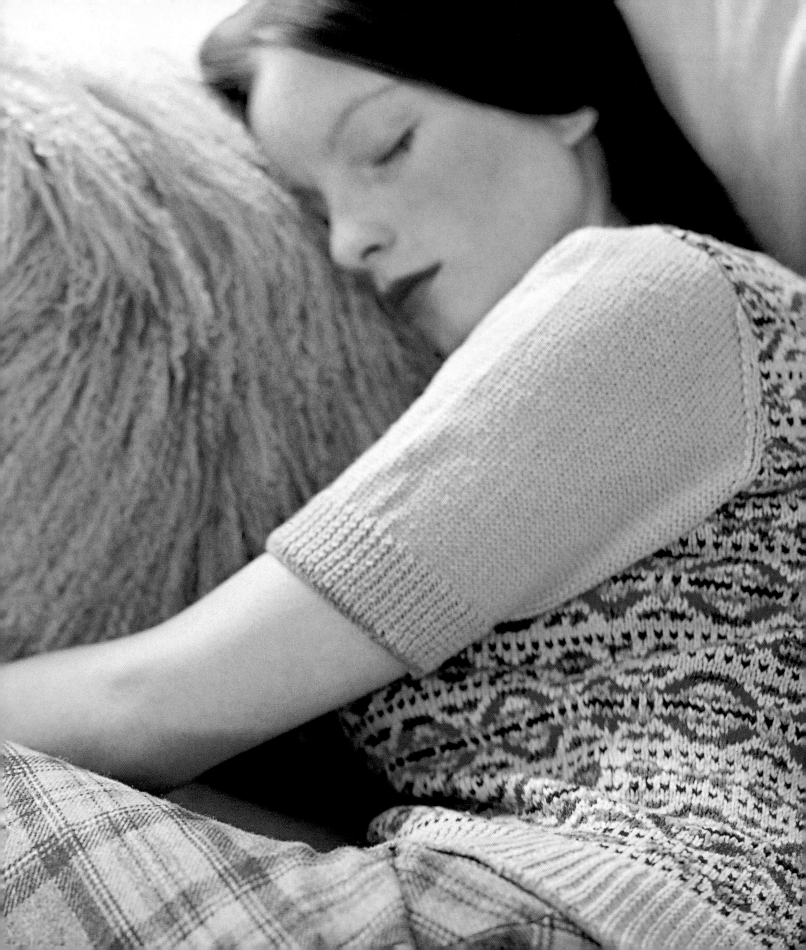

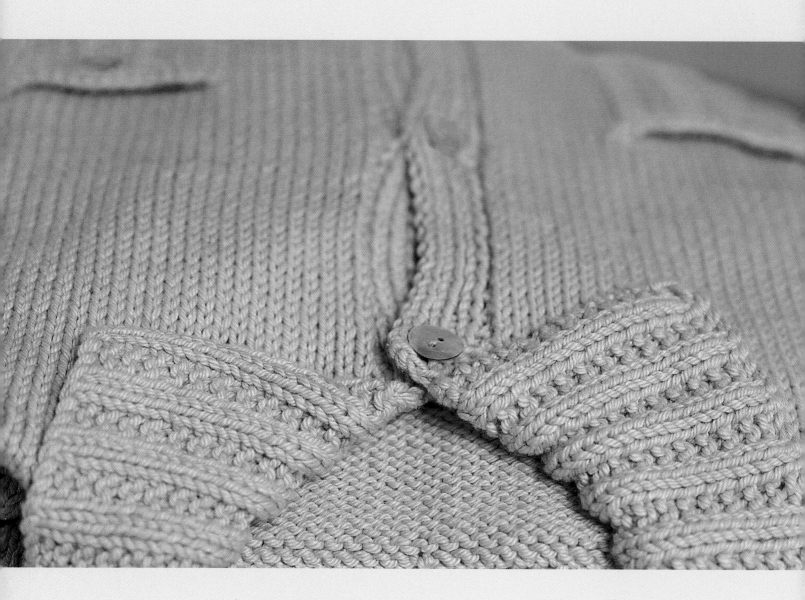

Long-sleeved cotton jacket SEE PATTERN ON PAGE 74

The shape of this button-through ribbed cardigan is reminiscent of a contemporary
denim jacket and translates well into a casual, sporty separate.

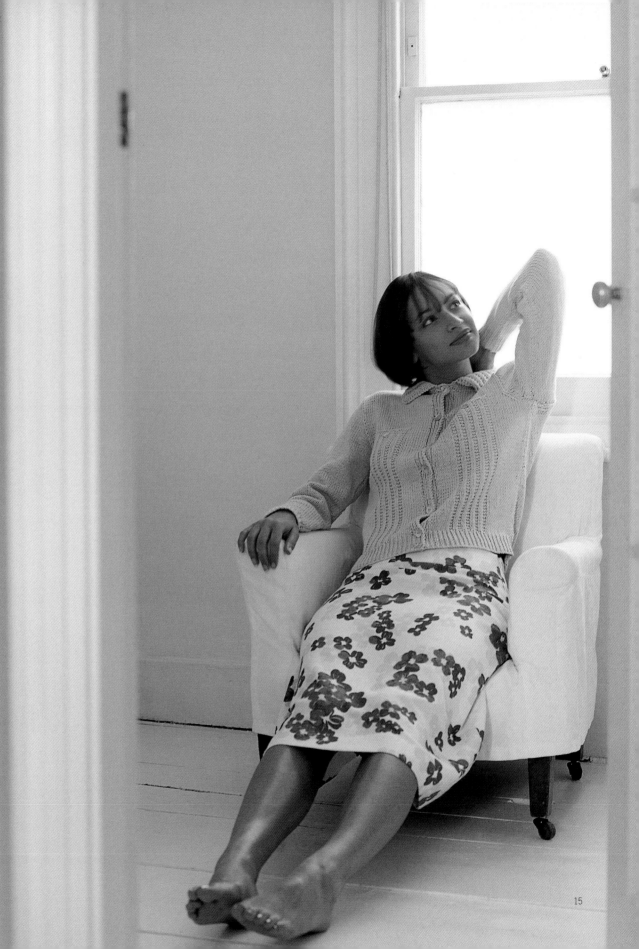

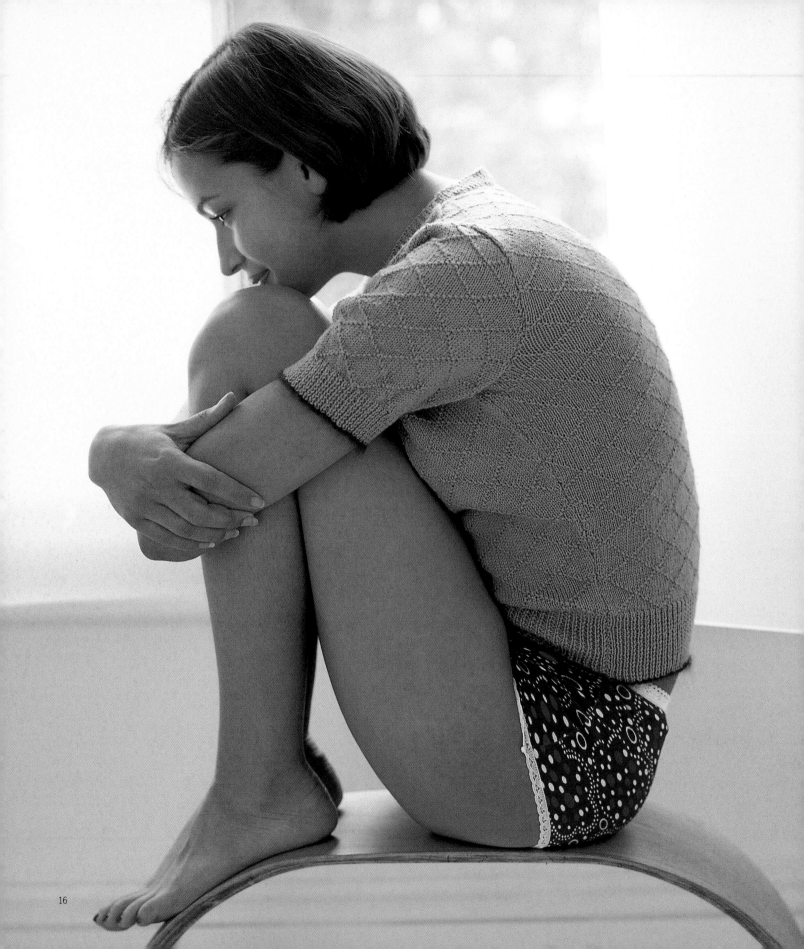

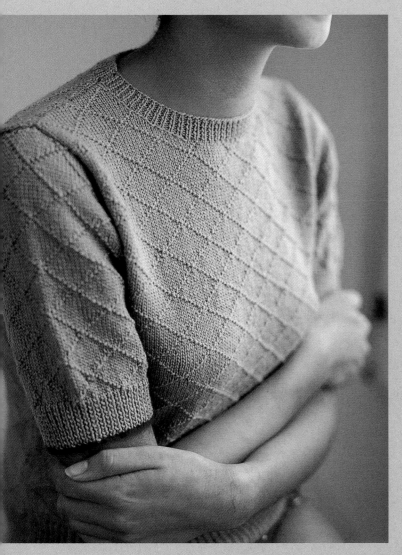

Short-sleeved diamond stitch sweater

SEE PATTERN ON PAGE 76

Short-sleeved sweaters were
the staple of most women's
wardrobes. Women did not have
the number or choice of clothes
they have these days. They were
trans-seasonal and could take a
wardrobe through from winter
to summer, as shown with this
delicately textured little sweater.

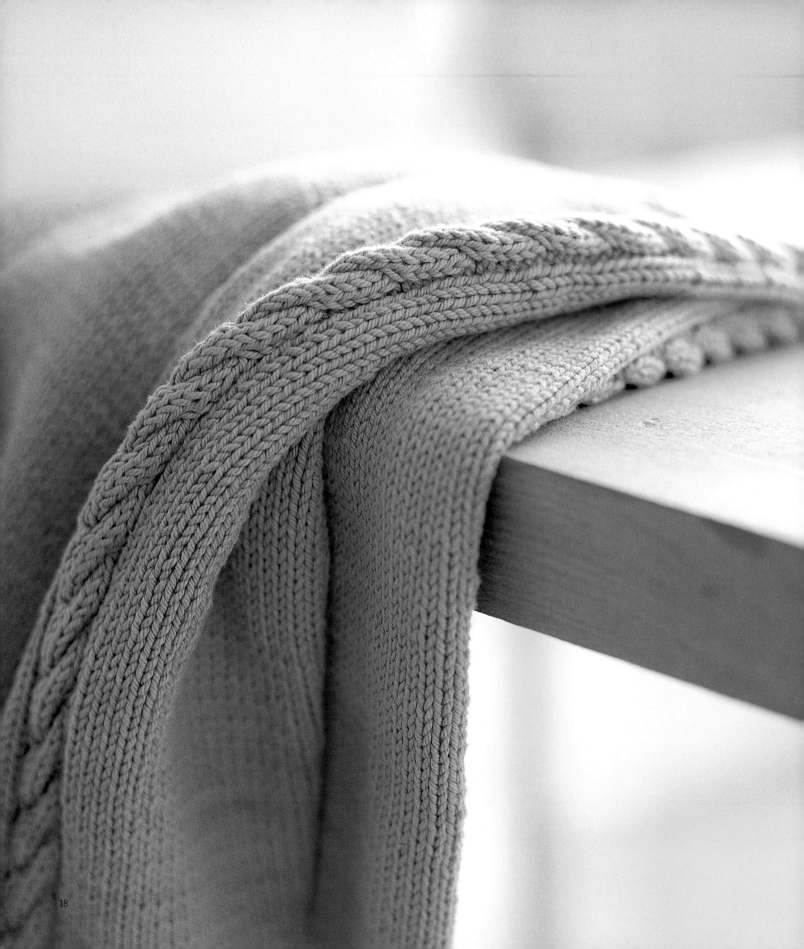

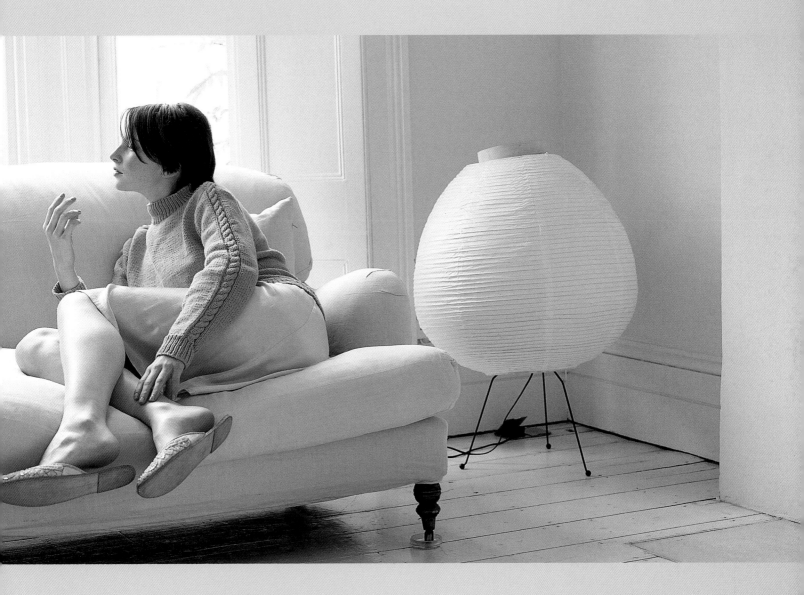

Cable sweater SEE PATTERN ON PAGE 78

A cable takes up more yarn than stockinette stitch. In the 1940s, few patterns incorporated

cables as yarn was in short supply. Therefore cables were used sparingly as details.

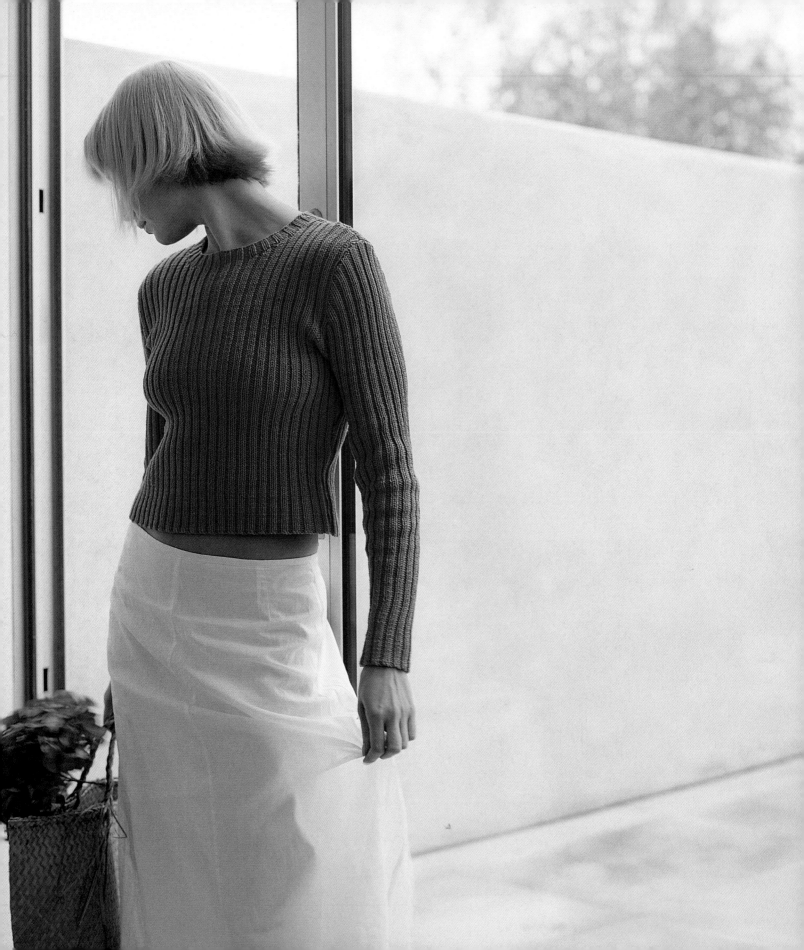

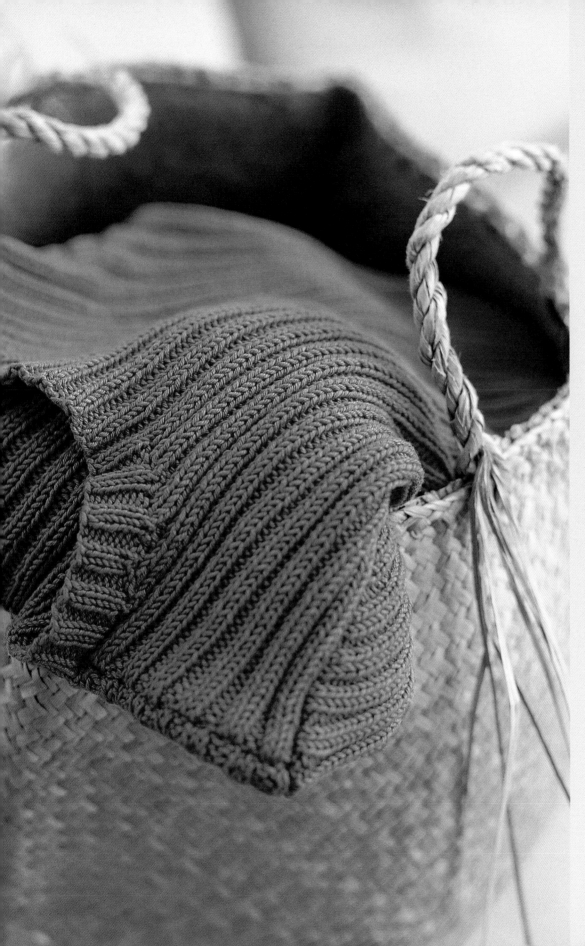

Ribbed sweater

SEE PATTERN ON PAGE 80

Throughout the period, the emphasis in fashion was on a tiny waist. It was not unusual for women to have a waist of 21 inches or smaller. Knitting patterns used devices like this rib to accentuate the style.

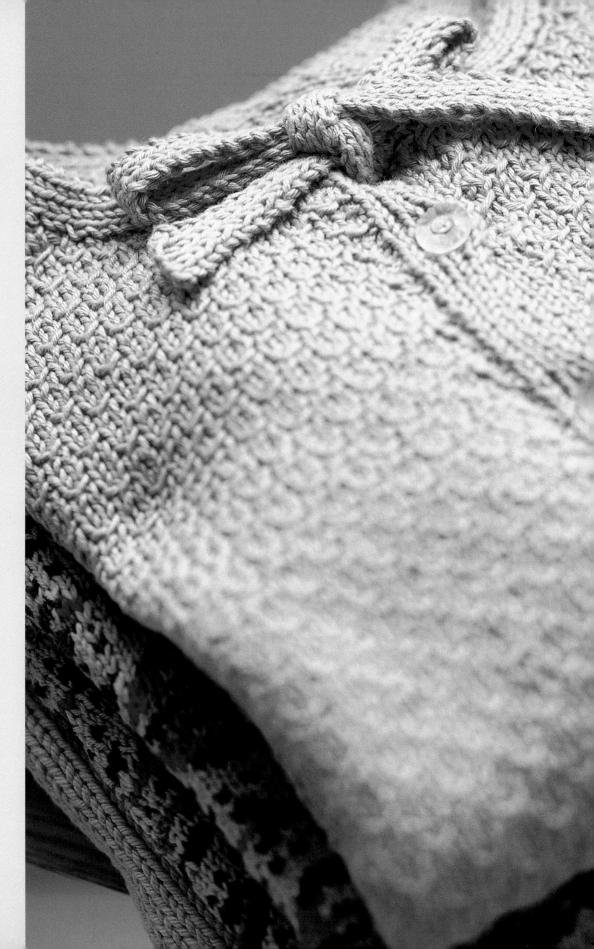

Short-sleeved cardigan with bow

SEE PATTERN ON PAGE 82

When supplies of yarn were scarce, particularly during the forties, worn-out sweaters were unraveled and the wool re-used to make new garments, often using a stitch structure so that any imperfections in the reclaimed yarn were disguised.

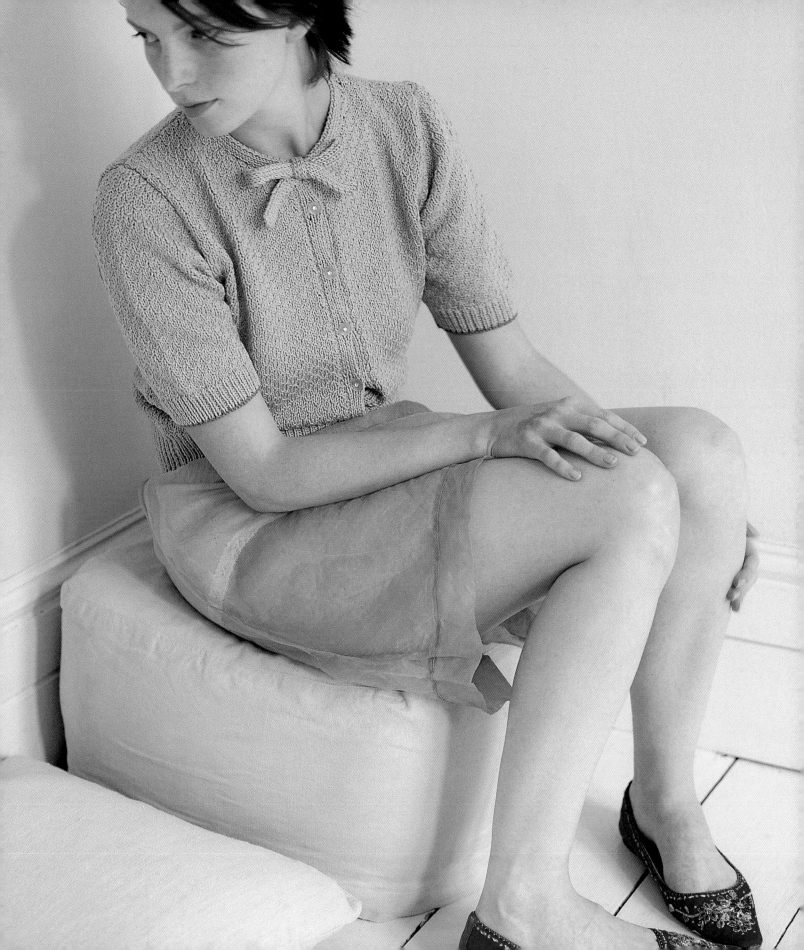

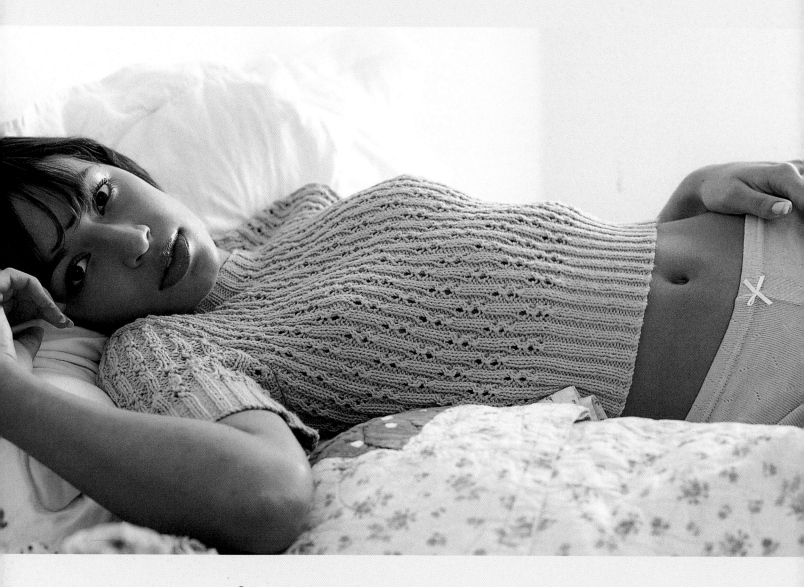

Short-sleeved ribbed lace sweater PATTERN ON PAGE 84

Though part of a twinset (see the cardigan overleaf), this charming short-sleeved sweater with its
pretty ribbed lace stitch works equally well worn on its own without the cardigan.

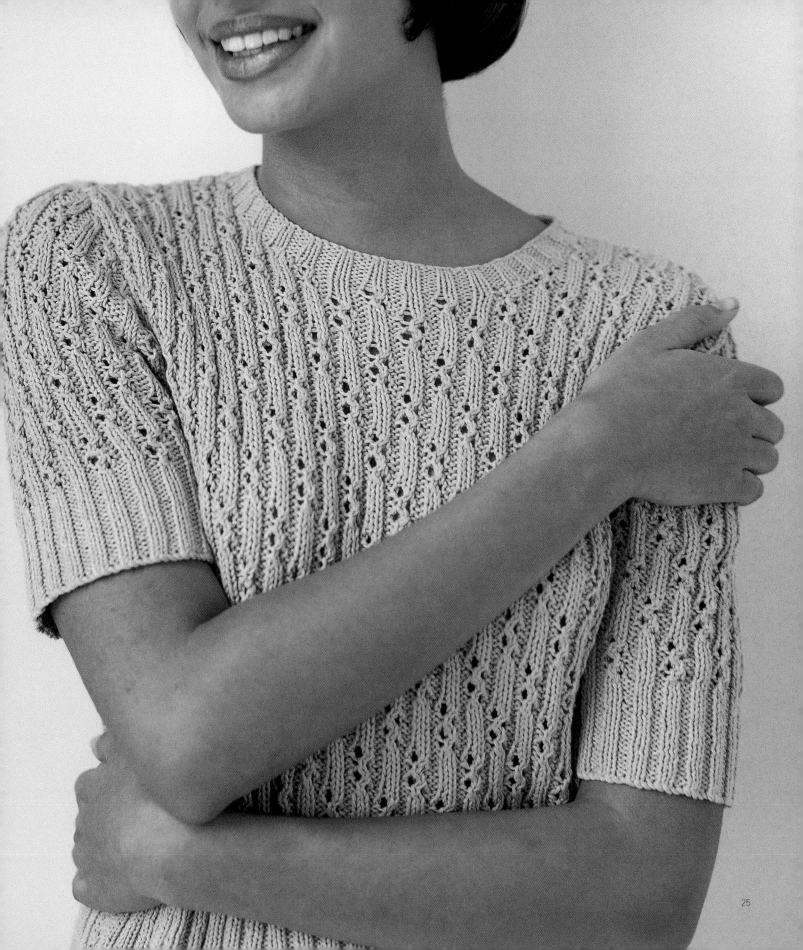

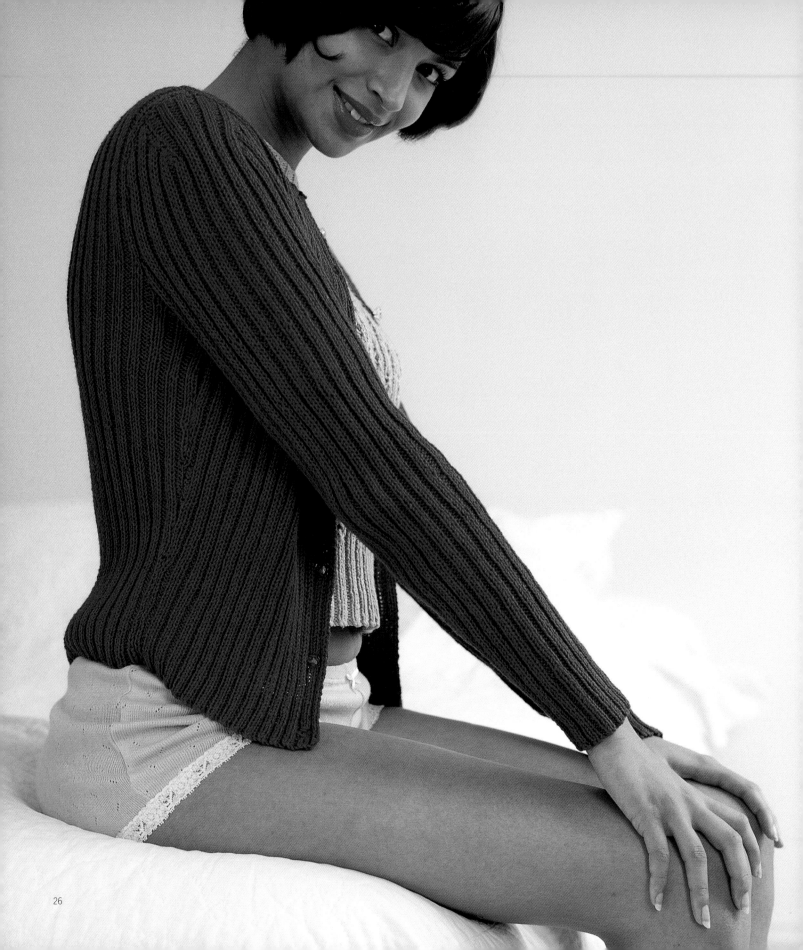

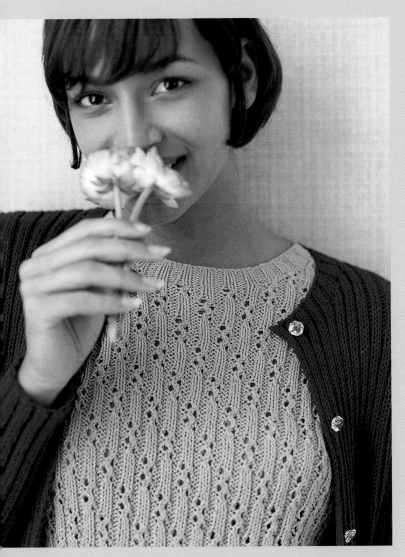

Long-sleeved ribbed cardigan

SEE PATTERN ON PAGE 86

There is now a greater choice of yarns available to the knitter, such as the linen mix yarn used to knit this twinset. A modern twist to the twinset is to knit the sweater in a contrasting color to the cardigan.

Short-sleeved sweater with mohair stripe

SEE PATTERN ON PAGE 88

Novelty yarns were used sparingly but to great effect, as reflected in this stylish sweater.

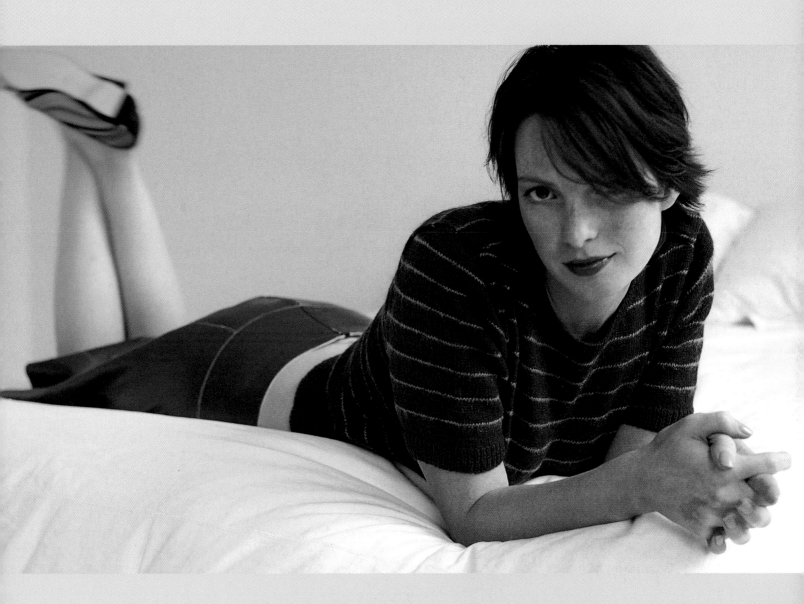

Fluffy sweater

SEE PATTERN ON PAGE 90.

This pretty sweater is simple
to knit and has enough detail
in the cabled ribs to make it
special. A mohair mix yarn
was chosen to keep the spirit
of the original design.

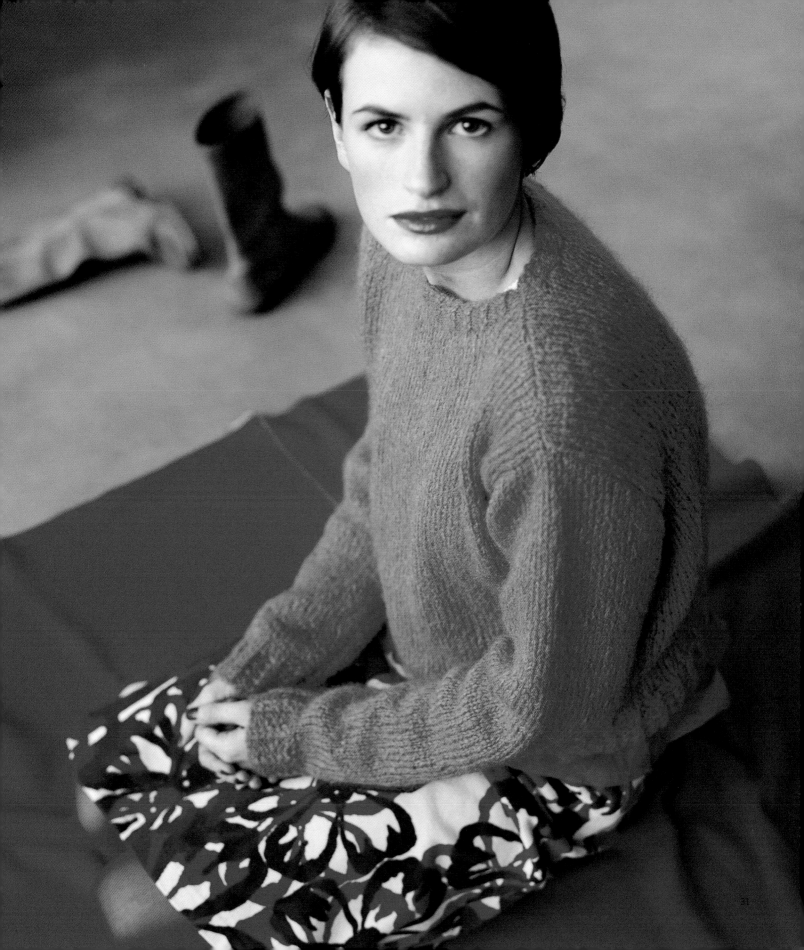

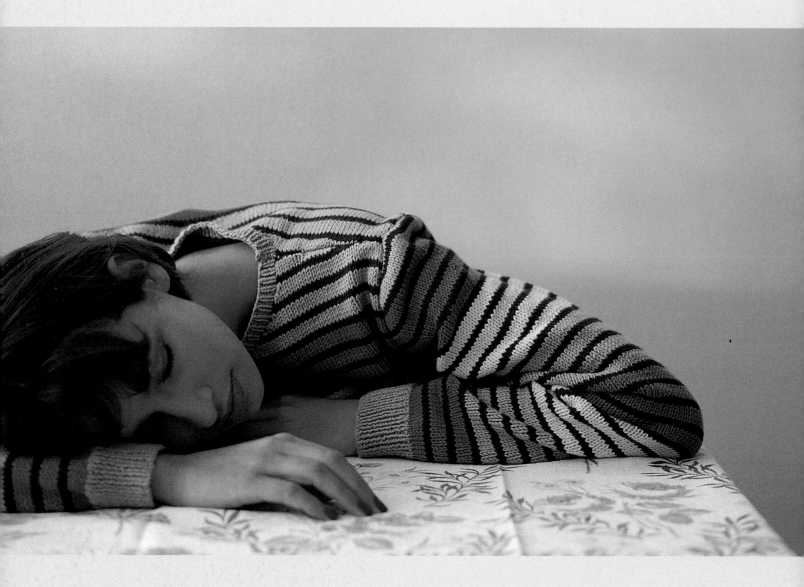

Long-sleeved striped sweater SEE PATTERN ON PAGE 92

This very graphic, modern design is created with larger blocks of colored stripes

and the sharp contrast of thinner, more narrowly spaced burgundy colored stripes.

A sophisticated design, which is nevertheless easy to knit.

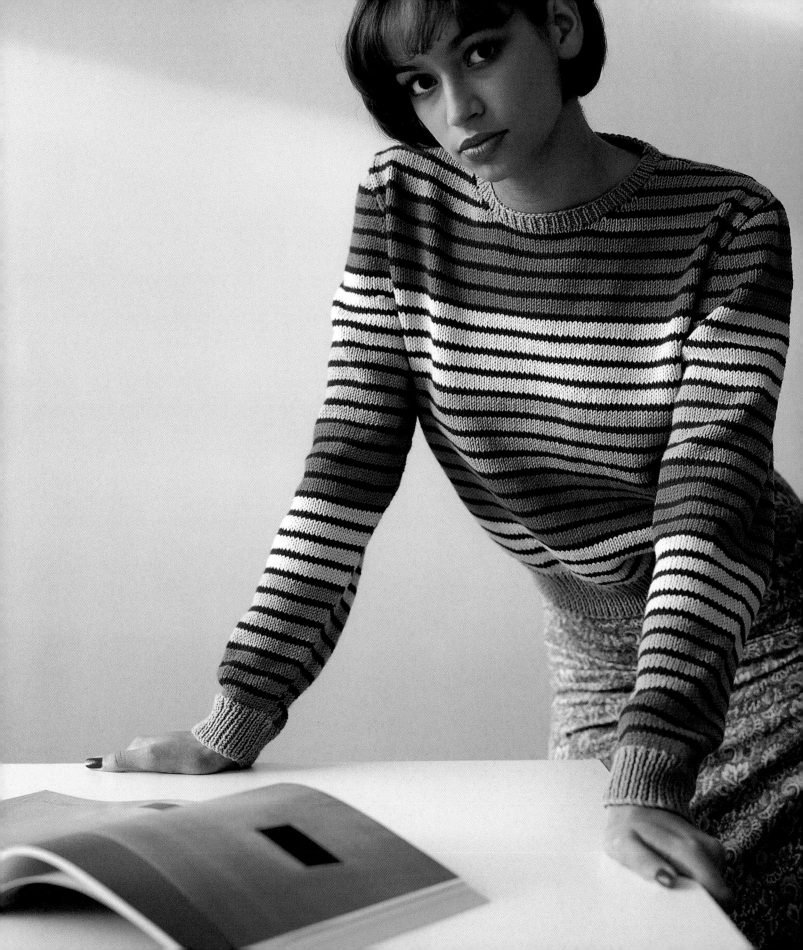

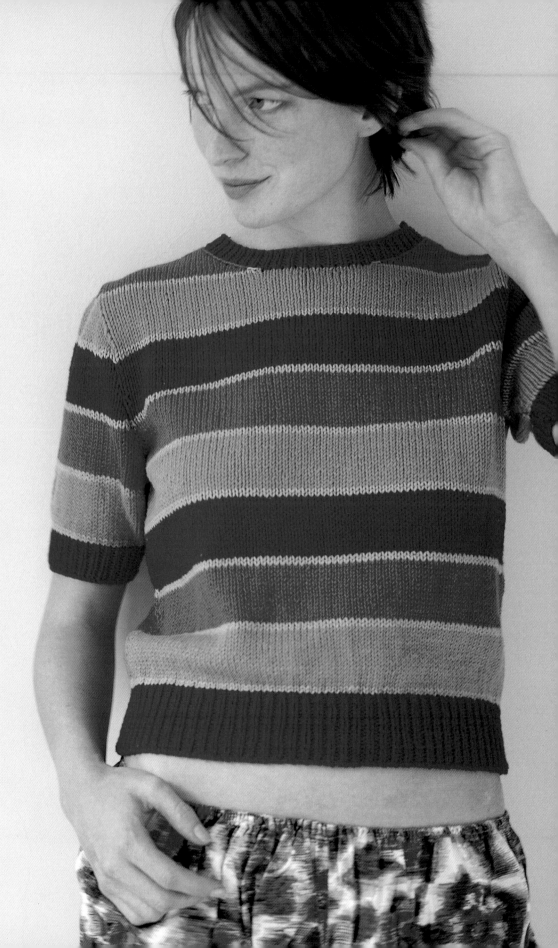

Short-sleeved striped cotton sweater

SEE PATTERN ON PAGE 94

The development of new yarns in a wider and exciting choice of colors has inevitably broadened the scope for the knitwear designer. By updating the yarn and the colors this simple sweater looks very modern.

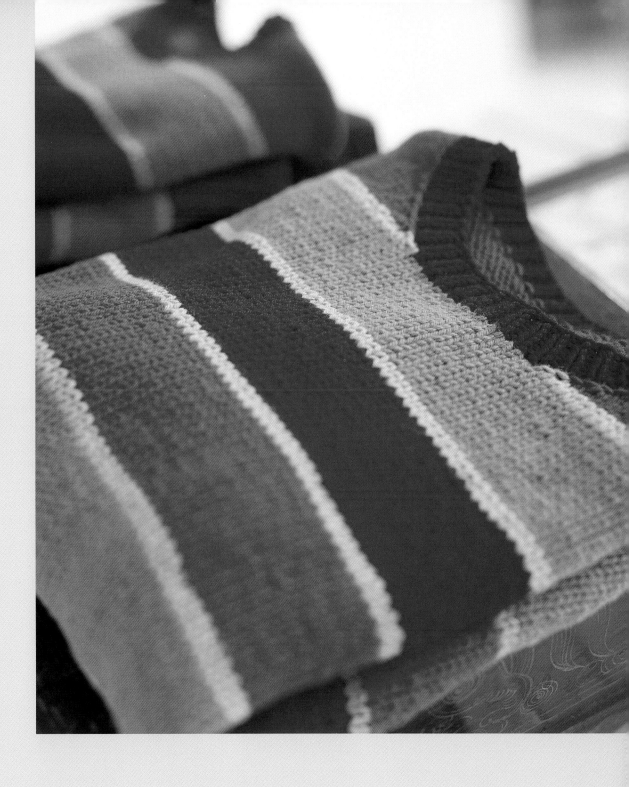

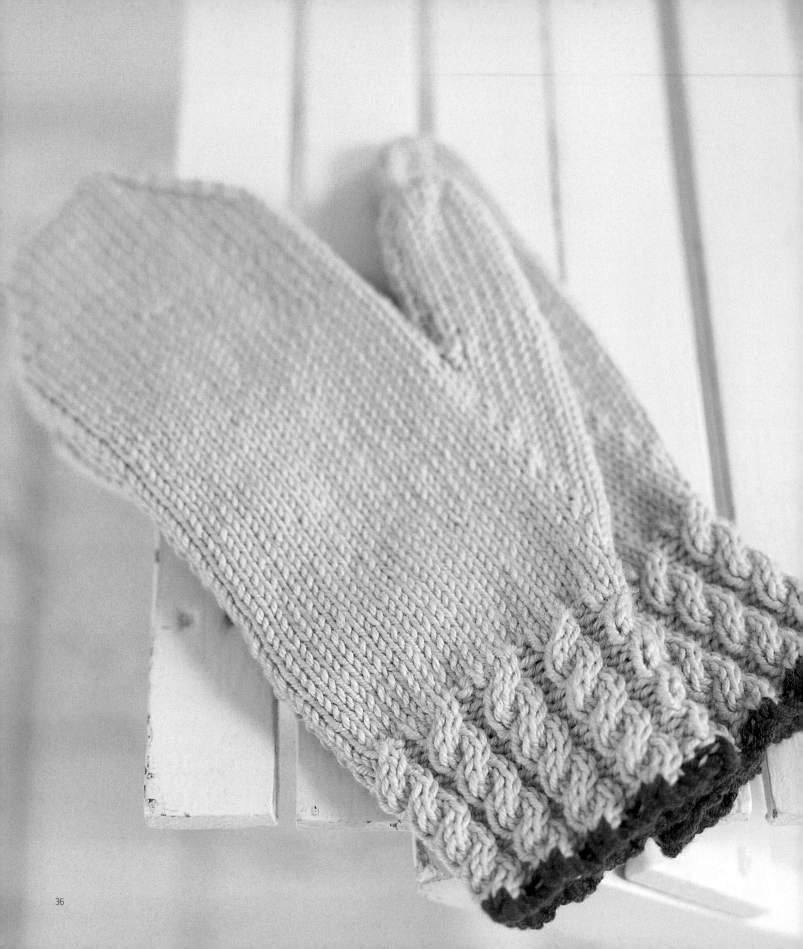

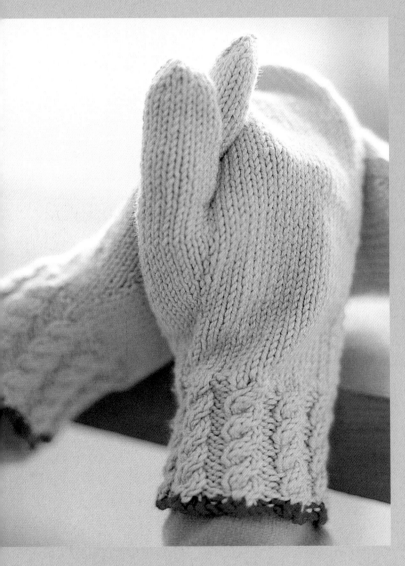

Mittens with cabled ribs

SEE PATTERN ON PAGE 96

Through the long, cold winters
it was essential to wrap up
warm. These mittens could be
knitted with odds and ends of
leftover yarn.

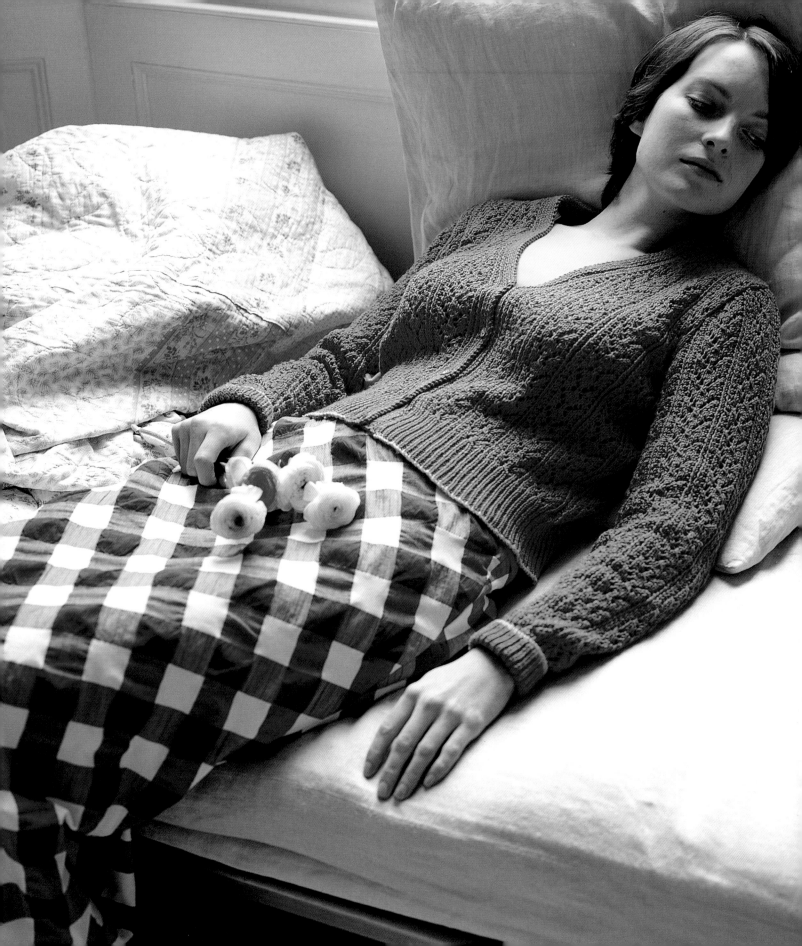

Lace cardigan

SEE PATTERN ON PAGE 98

The use of a contemporary yarn such as the cotton used to knit this cardigan really defines the structure and enhances the look to this lacey stitch.

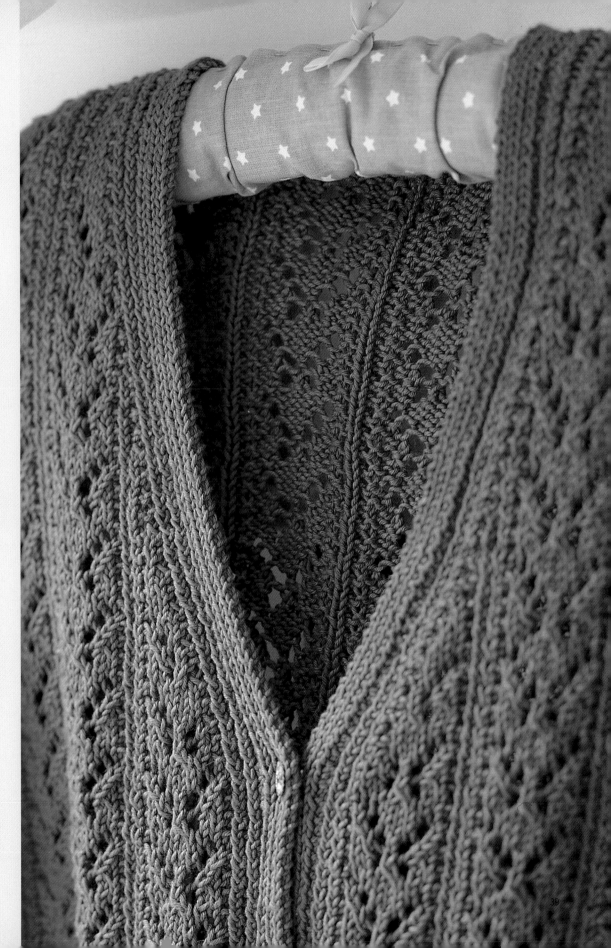

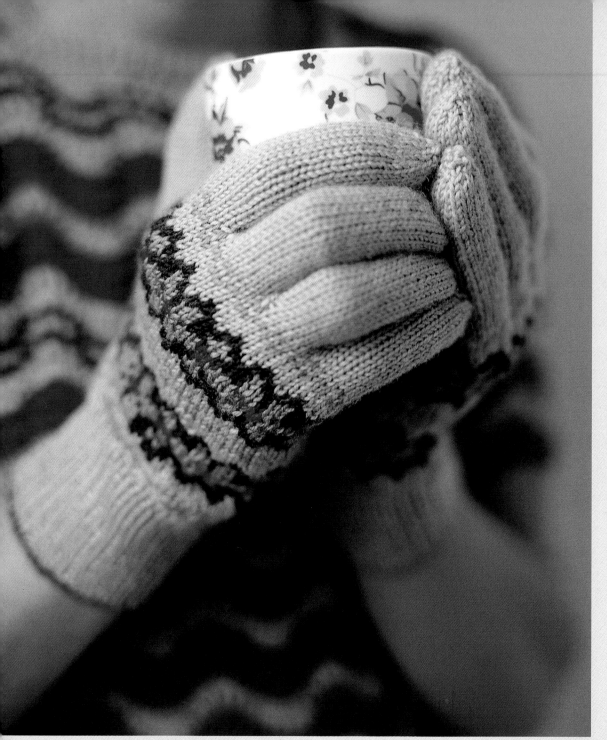

Fairisle gloves
and beret

SEE PATTERNS ON PAGES 100 AND 101

A pair of fairisle gloves and a
matching beret—and matching
was the vital word at this date.
No woman considered herself
to be well dressed unless her
accessories—hat, shoes, gloves,
and handbag—all toned with
each other, and with her outfit.

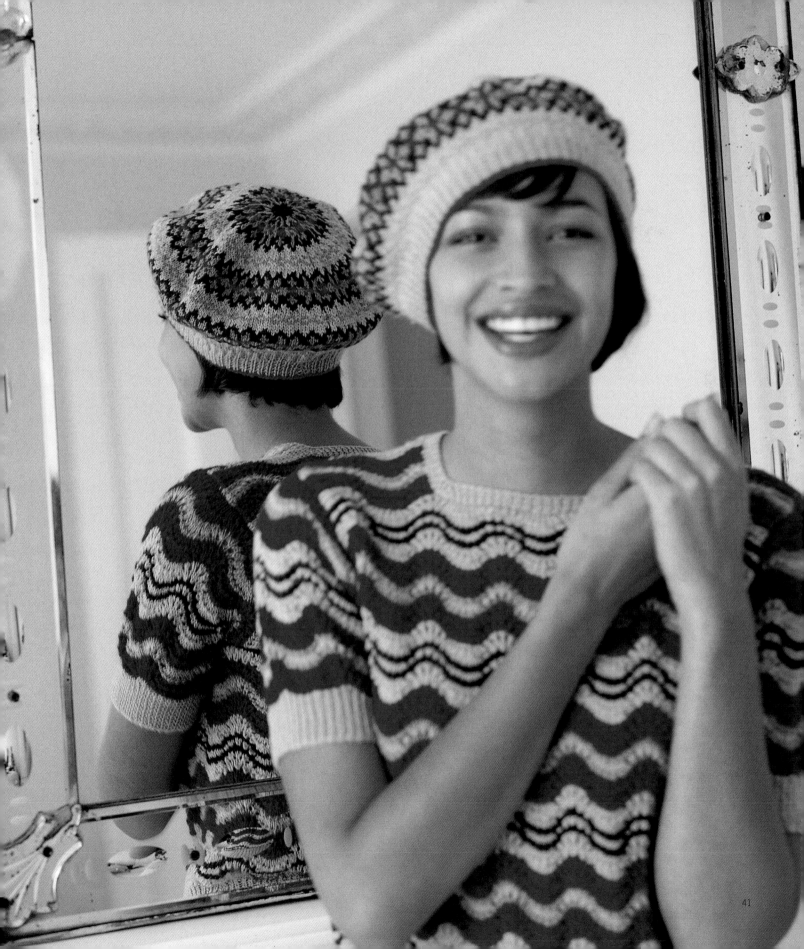

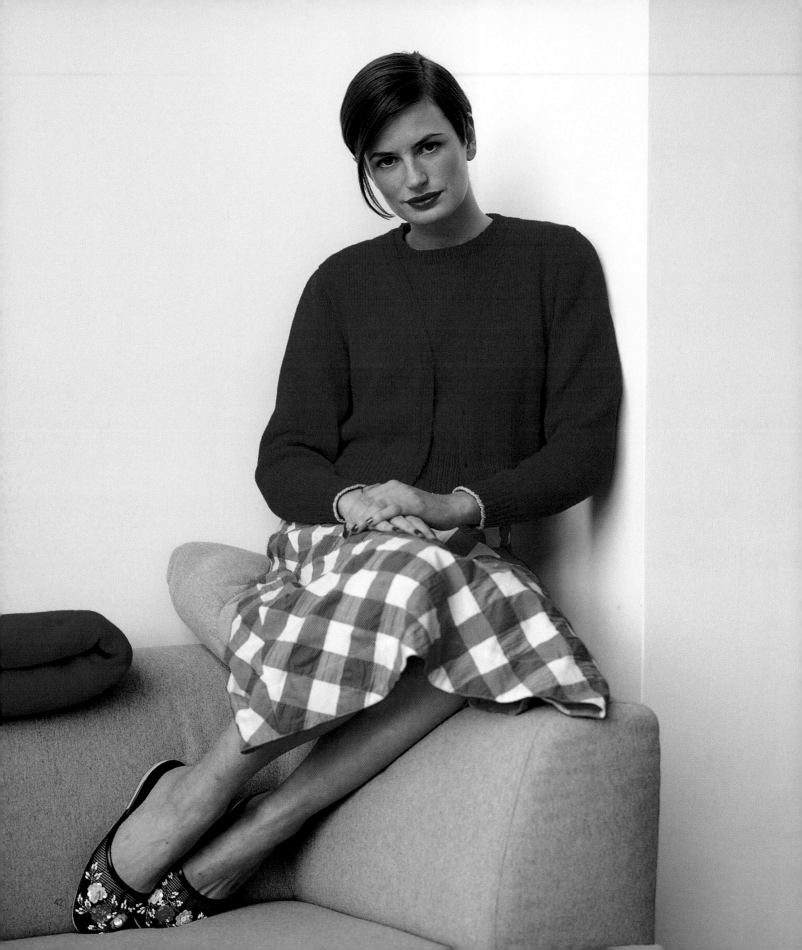

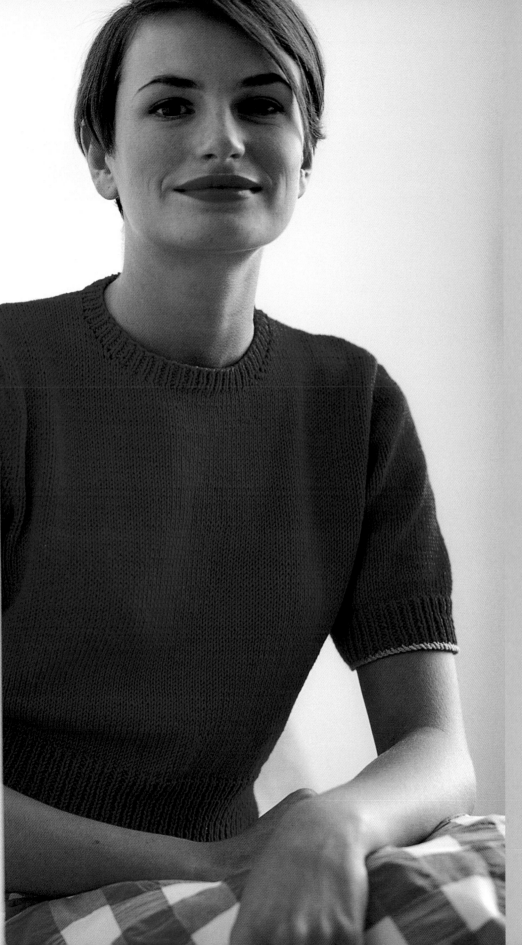

Cotton twinset

SEE PATTERN ON PAGES 102 AND 104

Twinsets were fashionable in the
1950s. The cardigan provided a
smart yet less formal alternative
to the tailored jacket. Suits, or
tailormades as they were called,
were both expensive to buy and
difficult to make if you were a
home dressmaker.

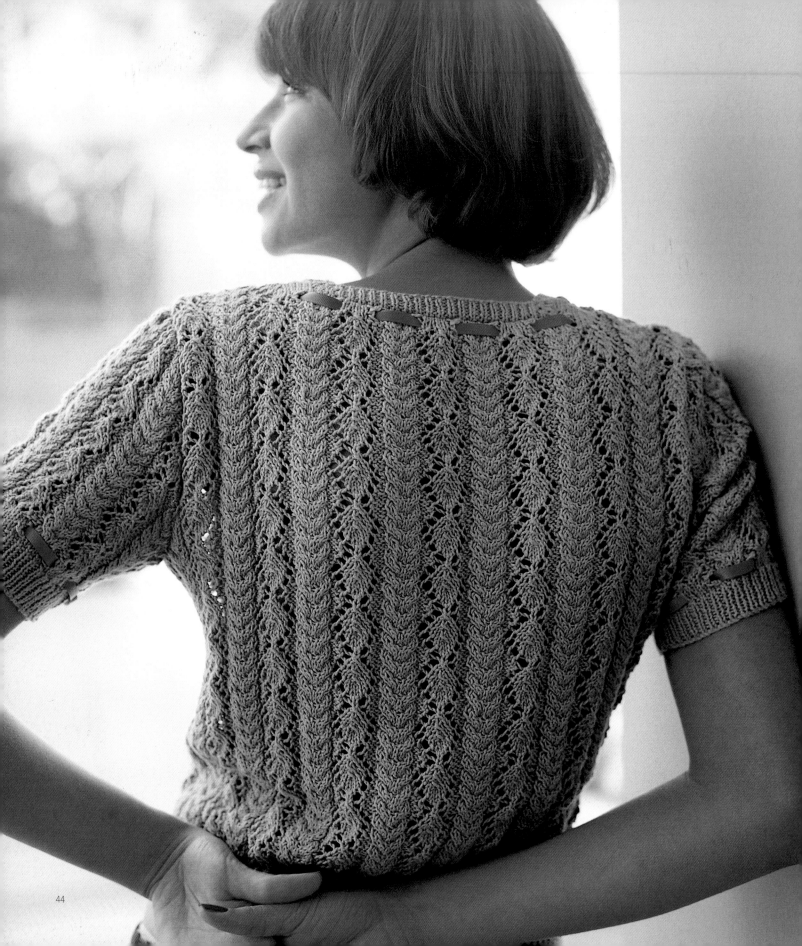

Short-sleeved lace sweater with ribbons

SEE PATTERN ON PAGE 106

The upswept hairstyle defines the original pattern as vintage. But this charming short-sleeved lace patterned sweater can look as modern today as it did fifty years ago when it was first knitted. Give it the personal touch by threading through different colored ribbons to go with different skirts and trousers.

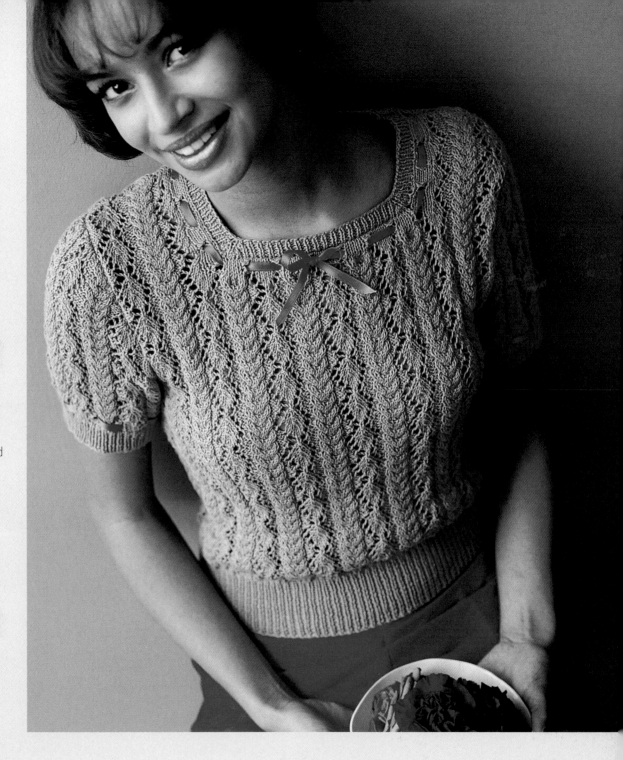

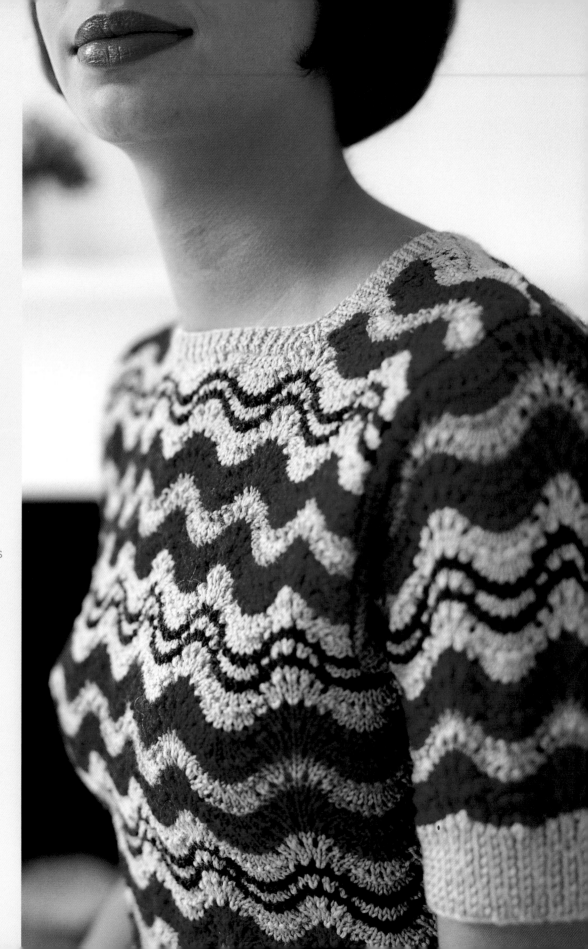

Short-sleeved wavy line sweater

SEE PATTERN ON PAGE 108

Knitting patterns and fashion photographs in magazines were mainly printed in black and white at this date. To give readers and knitters a good idea of the exact colors of a garment, copywriters used descriptive phrases such as, 'beech brown,' pearl grey,' 'china blue,' and 'bird feather brown.'

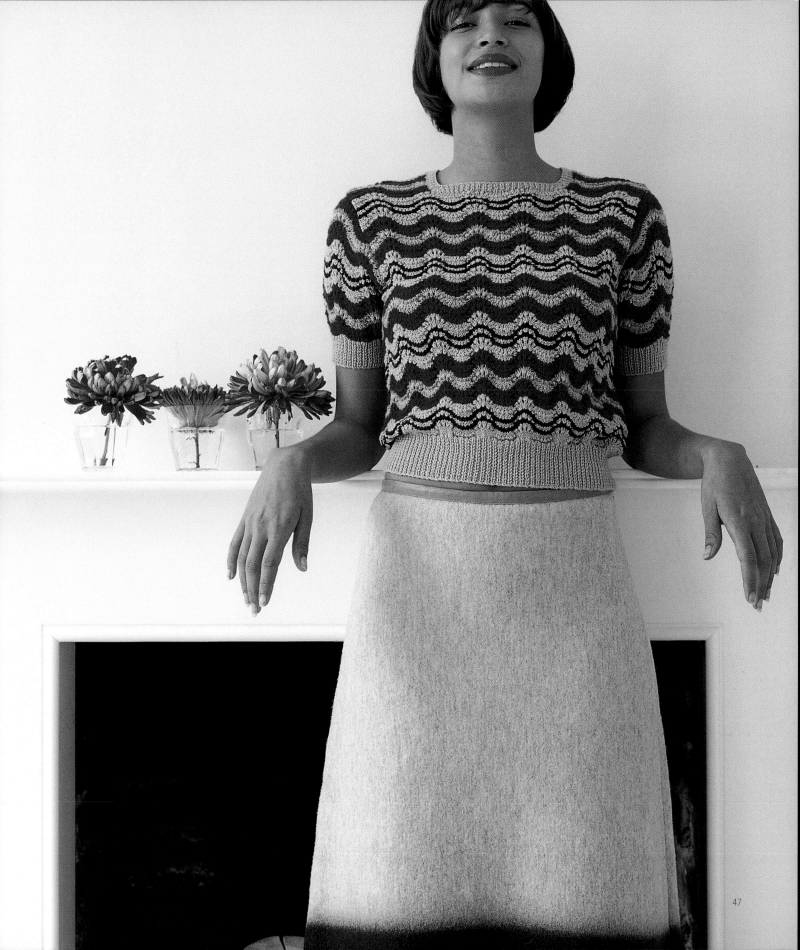

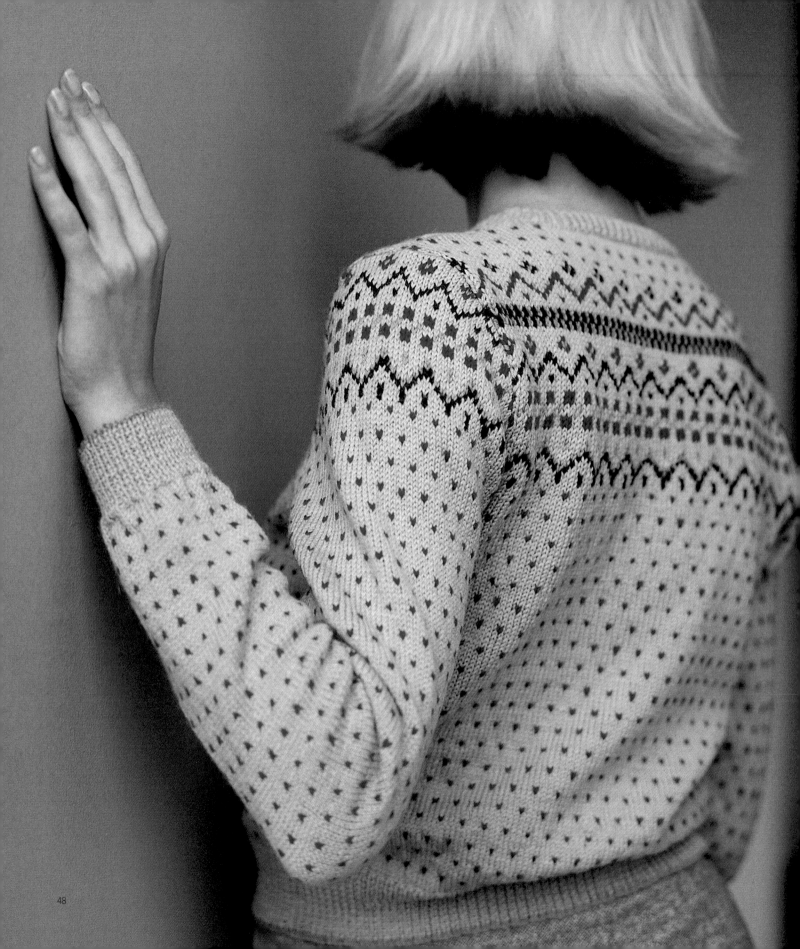